C O N T E N T S

INTRODUCTION

Hollywood. Perhaps no other word has evoked so much imagery or seduced the masses on quite the scale as has the name of the capital of filmdom. Blazing sun, soaring palms, turquoise swimming pools, blond starlets with their Afghan hounds racing down eucalyptus-lined lanes, stately limousines depositing ermine-draped stars to klieg-light-illuminated premieres. They all bespeak Hollywood. As proof to the unfortunates who stayed behind, tourists, adventurers, and the unending procession of Hollywood hopefuls sent back rectangular images of a world that seemed unreal unless you were there in person. Postcards more than a telephone call or letter verified the splendid mansions along Sunset, the strange magnificence of Grauman's Chinese and Egyptian theatres, the nightclubs where moviedom royalty romped, and the radio stations and movie studios that were the blood and guts of this make-believe world.

With these images so vividly implanted in the public's mind, it is difficult to remember that the roads of Hollywood weren't lined with stars when the city was founded. Contrary to the notion that Hollywood was a fertile movie ground at its birth, this Los Angeles suburb was a quiet agricultural community inhabited by Midwesterners content on land parcels surrounded by fields of mustard and strawberries. The semitropical climate and fertile land produced weather and vegetation peculiar to Eastern eyes, and visitors to the Southland often found themselves taking sidetrips to the Cahuenga Valley for sightseeing and perhaps hunting at one of the lodges there. Shortly after Hollywood got its name from the spouse of founding father Harvey Wilcox (she adopted it from a friend's summer home in the East), Hollywood received its first bona fide tourist attraction through the renown of watercolorist Paul de Longpre. An artist of international repute, de Longpre left Paris and after a brief stint

Hooray! FOR HOLLYWOOD

A POSTCARD TOUR OF HOLLYWOOD'S GOLDEN ERA

Jim Heimann

Chronicle Books
San Francisco

For Roleen and Zoè
and the swap meets and postcard and
paper shows of Los Angeles

Acknowledgments
Special thanks to David Barich and Bill LeBlond
for their help in seeing this project through.
And to the nameless photographers, tinters,
and publishers who so thoroughly documented
a land that can now only be imagined.

Postcard Publishers
Bolton: page 35; Brookwell: pages 57 (bottom
left), 86, 90; California Postcard Company:
pages 16, 20, 21, 22 (top), 36, 38, 39, 40, 41,
42, 46, 78; Detroit Publishing Company:
pages 18, 19, 21 (left); Frasher: pages 56
(left), 57 (top right), 66, 67, 71; Gardner
Thompson: page 59; M. Kashower Company:
pages 17 (bottom), 37, 48, 49, 56 (right), 80,
back cover; E.C. Kropp: pages 26, 51, 62, 64,
65, 73; M.B.Libman: pages 70 (bottom), 74
(top and bottom); Neuner: page 27 (right);
Pacific Novelty: pages 47, 50, 60 (top left);
Bob Plunkett: pages 32, 34, 52, 53, 57 (top
left), 70 (top left); M. Reider Publishing: pages
22 (bottom); Souvenir Publishing: page 17
(top); Curt Teich: pages 27 (left), 28 (right) 31,
63, 96, front cover, back cover; Tichnor:
pages 25 (bottom), 29, 33, 57, (bottom right),
76, 81, 84 (top left, bottom left and right), 85
(top right, bottom left and right), 87; Van
Ornum: page 44; Western Publishing and
Novelty Company: pages 2, 14, 15, 23, 43,
54, 55, 60 (bottom left) 68, 69, 72, 83, 84
(top right), 85 (top left), 88, 89, 91

ISBN: 0-87701-301-2

Book and cover design by Paul Mussa
Produced at Triad, Fairfax, California
Composition from Type by Design

Chronicle Books
870 Market Street
San Francisco, California 94102

in New York moved to Los Angeles, where the climate was more conducive to growing the flowers he painted. Sojourns to the suburbs of Los Angeles netted him a wide variety of floral specimens, and many times he stopped in Hollywood to gather flowers and exchange pleasantries with a French tavern keeper there, Rene Blondeau. A successful exhibition of his paintings allowed de Longpre to settle in Hollywood and establish a Moorish mansion complete with lush gardens. His home soon became a mecca for tourists quenching their thirst for California exotica, and when they returned home they brought the name Hollywood with them.

Although still a strict prohibitionist town with Midwest manners, several other residences added to the milieu that gave Hollywood its exotic flavor even before the movies gave the city an international reputation. Edmond Sturtevant's estate near Franklin and Western avenues was another lushly dressed paradise. In large ponds he grew several species of water lilies, some large enough to support young children who were sometimes photographed on them. Completing the unusual landscape were pineapple fields, rose gardens, rows of sweet peas and poinsettias, lanes of banana palms, and, of course, acres of citrus. Among the other mansions that dotted the hills, Adolph and Eugene Bernheimer, oriental-art importers, built an imposing Far Eastern palace they named Yamashiro. There was also Glengarry Castle, a combination Scottish-German manor whose baronial halls were filled with armor and tapestries. And so the landscape of Hollywood was already being molded into the land of make believe that was to characterize it in its new role as tinseltown.

The movies came to Hollywood rather undramatically. Mostly entrenched on the East Coast, film companies began their westward journey when members of the Chicago-based Selig Company arrived briefly in Los Angeles in 1907 scouting locations. The company permanently settled near downtown in 1909. The 350 days of sunshine boasted by the Chamber of Commerce was a tremendous lure but escaping the patent detectives on the East Coast was another inducement. Within a few years, the Bison, Biograph, New York Motion Picture, and Kalem companies had all

moved to the Los Angeles vicinity. On October 27, 1911, the Nestor Film Company of Bayonne, New Jersey established the first Hollywood movie studio in the Blondeau Tavern on the northwest corner of Sunset and Gower. Film companies had always enjoyed the scenic beauty and variety of topography of Hollywood and its surrounding area that allowed them to shoot unlimited types of films without having to leave town. The Nestor Company, fully aware of these advantages, soon began turning out reel after reel, amazing their competitors in the East. They soon followed, firmly establishing Hollywood as the film capital of the world. Carl Laemmle formed the Universal Film Manufacturing Company in 1912, which incorporated the Nestor Film Company and their offices at Sunset and Gower. In 1915 he moved to the San Fernando Valley and opened his Universal City. Visitors to Universal City got a peek at the process of making films through tours and a restaurant where the public could dine with the stars.

In just a matter of years Hollywood boomed from a quiet residential community to a bustling city dotted with barnlike studios, host to an endless parade of drama played out in its dusty streets. Homes, ranches, streets, and commercial buildings became backdrops for Westerns, robberies, chases, beauty pageants, jungles, and virtually every location on earth. Looming Babylonian palaces replaced orange groves and medieval castles competed with New York skylines against a sunkissed sky. Hollywood the movie town had arrived.

By 1920 the naive halcyon days of Hollywood were over. In a mere decade the movies had transformed the entertainment habits of the world and Hollywood was at the center. The success and popularity of stars such as Mary Pickford, Charlie Chaplin, the Gish sisters, Fatty Arbuckle, Valentino, and Gloria Swanson brought a stampede of young and old hopefuls wishing to gain fame and fortune in this California Eden. During the population boom of the twenties, some studios moved to nearby Culver City, Westwood, and San Fernando Valley; residences moved westward to Beverly Hills and Brentwood, but the bulk of the machinery that made the cameras roll remained in Hollywood proper. And the word "Hollywood" began to mean any place where the movies were.

The onslaught of people demanded civic improvements, and dusty lanes were soon paved. Hospitals, schools, post offices, and libraries replaced orchards. Bungalows lined former fields, and, in pace with the sum of money earned by the motion pictures, hotels, nightclubs, restaurants, theatres, and cultural outlets were established. The Hollywood Hotel, Sid Grauman's Egyptian and Chinese theatres, the Montmartre, the Hollywood Bowl, and the Pilgrimage Theatre now entertained what had been a quiet village of agrarians. Meanwhile, studding the hills above the burgeoning metropolis, Normandy estates, Tudor mansions, and Spanish villas began to supplant the exotic gardens and homes of a decade before. Flushed with salaries that spiraled to the unbelievable, stars, producers, and directors invested their rewards in dreamlike domiciles that matched the film world of make-believe.

Pickfair, the residence of Hollywood's most famous couple, Mary Pickford and Douglas Fairbanks, became the social center of the community, attracting royalty, society, and politicians. Tours of the famous residences became a popular diversion for the visitor to Hollywood anxious to see and report back home the opulence in which stars lived. The name of Hollywood's main street, Prospect Avenue, was changed to Hollywood Boulevard, and it too reflected the changing standards brought by the new wealth. Trading its mercantile image for something a bit more uptown, Hollywood Boulevard began to sport exclusive haberdasheries and salons befitting a well-heeled clientele. Agents' offices, dance studios, and hotels began to cluster along the Boulevard, and with nearby Vine Street, home to the Brown Derby, radio stations, and casting offices, earned the title of "the Crossroads of Movieland."

The tabloids and fan magazines that chronicled the lives of the movie stars also provided endless prose on the virtues and vices of the city that housed them. The naive reputation of Hollywood's first decade was replaced with a slick formula stereotype of the city of sun and sin and that image was fixed in the public's mind. But even with the inevitable scandal or two, the portrait painted of Hollywood was often pale for the tourist looked for a wild party or movies being filmed in the street. The boomtown may have appeared in the press as a wild and wooly place, but by 1926 forty

thousand people resided and worked in Hollywood, and it could have posed as a Midwest cousin by the sea.

To accommodate the hordes of tourists making the pilgrimage to the land of their idols, a variety of hotels had opened, catering to various needs and pocketbooks. The venerable Hollywood Hotel, where Valentino tangoed was an institution by the twenties. To the west, the Garden of Allah was the creation of actress Alla Nazimova, and it attracted long-term residents such as F. Scott Fitzgerald and Robert Benchley. It was also the scene of innumerable parties and trysts, and even murders. The Beverly Hills Hotel was out in the country when it opened in 1912. By the twenties it too was a place where starsighting was guaranteed. Back in downtown Hollywood, the Christie, Plaza, and Roosevelt hotels all opened prior to the Depression. At the Plaza, Clara Bow hosted a club called the It Club, and at the Roosevelt's Blossom Room bands and stars played the night away. The Hollywood Athletic Club also provided residency for guests and stars and included a gym, pool, and other elegant amenities.

Expanding the cultural horizons of the residents, the Hollywood Bowl was the effort of a group of prominent Hollywood citizens who secured the money and property for a location to present outdoor theatrical performances. Initially the Bowl was a ravine where the audience stood in knee-high grass, but as popularity and revenue escalated the band shell and facilities improved until an all-steel shell and permanent seating were completed in 1929.

If the twenties were the ballyhoo years, the thirties saw Hollywood come of age. The movies and radio, though not immune to the Depression, maintained their financial ground and sustained the economic base of the town. The technological advances, culminating in the talkies, altered the product being created in the film factories, and an addicted audience demanded more sophisticated fare than the melodramas of the silent era. Some thirteen million people placed their quarters down to see such spectaculars as *42nd Street* and *King Kong*, the comedies of Mae West and the Marx Brothers, and religious epics like *The Sign of the Cross*. In this climate

where a studio averaged fifty films a year, the flatlands of Hollywood filled with bungalows, leaving nary a vacant lot in sight.

Meanwhile along the thoroughfares around Hollywood, nightspots offering food and entertainment to a new crop of stars enhanced Hollywood's reputation as a playground as well as workplace for the film colony. One of the earliest was the Montmarte on Hollywood Boulevard, a spot so hot it prompted a young Joan Crawford to dance the Charleston on its tabletops. Sunset Strip played host to innumerable nightclubs and by the end of the decade everyone knew the names Trocadero, Mocambo, and Ciro's. Big Bands played at the Coconut Grove and the Palladium, on Sunset near Vine, while across the street Earl Carroll was presenting his successful Vanities. Early jazz could be heard at Frank Sebastian's Cotton Club in nearby Culver City, and a bit of bohemia was available at the Paris Inn where stars flocked after a day at the film factories. Back in Hollywood proper, after a night on the town commoners could breakfast with the stars at the swank R. Schindler–designed Sardi's and later hear a nationally broadcast radio program from Tom Breneman's on Vine. The venerable Brown Derby hosted the cream of Hollywood's hierarchy presided over by gossip columnist Louella Parsons. And if a weary starlet or visitor still had the energy, a stroll with hundreds of roaming simians at Monkey Island on Cahuenga Boulevard might be in order.

When movie stars came to radio, radio came to Hollywood. In addition to the movie studios already established, the major radio corporations set up their broadcasting studios in the heart of Hollywood within blocks of each other. CBS opened new facilities on the site of Hollywood's first studio in 1938. The same year NBC completed its broadcasting plant down the street on the corner of Sunset and Vine. Together with ABC, also on Vine, the combined stations rivaled the broadcasting power of industry headquarters in New York.

The physical plants that were churning out the movies took on the appearance of fortresses after the arrival of the talkies. Gone were the days of the visitor to Holly-

wood stealing a peek at the process of movie making. Instead concrete walls were the most a newcomer or visitor could glimpse of the magical process going on within. As a substitute, a tour of the homes of the stars, a sightseeing staple since the twenties, was in order. The chateaus, palazzos, and haciendas that dotted the hills of a younger Hollywood soon found themselves neighbors to sleek moderne houses and ranch-style estates of second-generation stars. A tour of the stars' homes had once been a lazy meandering of the Hollywood area. It now became a journey encompassing the slopes of Los Feliz and the Hollywood Hills; westward to Beverly Hills, Bel Air, Brentwood, and the beaches; and even a side trip to the raw countryside of the San Fernando Valley.

Other attractions blossomed, appealing to both visitor and resident alike. The Pan Pacific Auditorium, a full-fledged streamlined wonder, opened in 1935 and housed expositions and ice-skating revues. Over on Sunset Boulevard the Crossroads of the World introduced a novel shopping mall with a nautical motif and shops in a European-inspired village. This incredible mix of commercial and residential architecture continued the make-believe tradition that was now so indelibly linked with Hollywood. With all the activity, social, civic, and movie related, the threat of war was never in the forefront of the imagery served to the public. Until the bombs were dropped on Pearl Harbor, it was business as usual. Then, however, the floodgates of patriotism were opened and Hollywood answered the call of duty.

Hollywood in the forties marked the beginning of the end of its golden era. But the initial war years in Hollywood were profitable and prosperous, echoing America's end to the Great Depression. During the war years, Hollywood was part of the defense effort, and the profits of the movie industry skyrocketed. Despite shortages and rationing, the studios churned out movie after movie. The newest tide of humanity to hit town was in uniform. Virtually every soldier who passed through southern California managed to set foot in Hollywood. If they had money, they could see an amazing array of entertainment. Most of the clubs and dance halls from the thirties were still in full swing.

The Hollywood Palladium across from Earl Carroll's on Sunset featured the best of big band music. Swing shift hours were in effect for most establishments, and Hollywood was pretty much an all-night town. For those servicemen short on cash, innumerable outlets offered discounts and a helping hand. Perhaps the most famous of these was the Hollywood Canteen, where a monthly headcount averaged 100,000. Almost all of Hollywood's stars put in duty as hosts, helpers, and kitchen crew. Food, cigarettes, and coffee were all free for the taking. Dancing was to big-name bands and servicemen could often dance with stars such as Paulette Goddard or Marlene Dietrich.

With the end of the war and a tumultuous impromptu party at Hollwood and Vine on VJ day, Hollywood entered the next phase of its life. The movie industry experienced dramatic change with a postwar recession and diminishing revenues. There was unrest by entertainment industry workers who wanted a larger part of the pot. Added were the Hollywood "witch hunts" by the House Un-American Activities Committee, which dampened the hardiest of spirits and effectively split the town in two. The rise of Las Vegas and the luring away of cabaret talent with massive salaries closed down many clubs that operated on a low overhead and intimate atmosphere. What hit Hollywood hardest however, in a way radio never did, was television. This basically free form of entertainment kept people home and away from the theatres. A new batch of stars, operating on their own and not backed by studio control, emerged and took advantage of both mediums. The immediacy of television was another selling point which kept viewers hooked on the tube. Whatever the reasons, Hollywood, the myth and town, had slipped to a point from which it would never recover.

The palms still sway, and the forecourt of the old Grauman's Chinese is still thronged with tourists, but the Hollywood of the golden era has mostly disappeared. The zealous tributes that crisscrossed the mails in the form of postcards endure, however, allowing the tourist, fame seeker, resident, and star to glimpse the pictures of the past and take their own journey through the make-believe land of Hollywood.

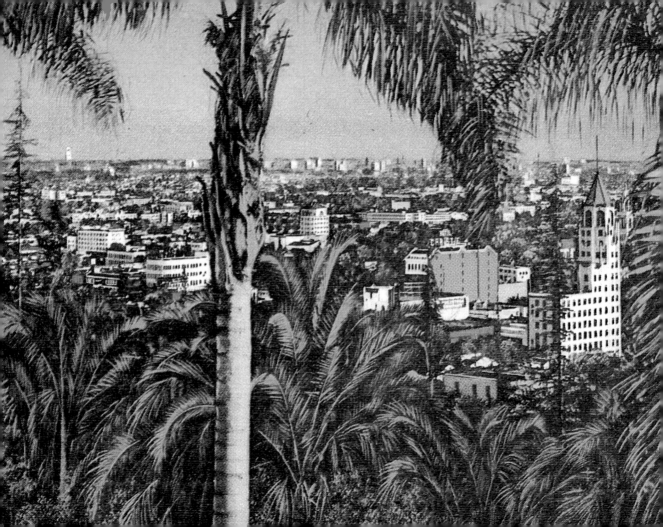

HOLLYWOOD: THE CITY

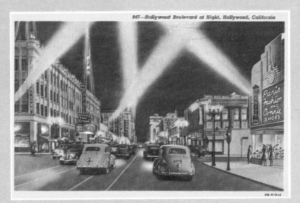

847—Hollywood Boulevard at Night, Hollywood, California

Hollywood in its golden era was a city of premieres and civic parades, of Keystone cops filmed in its streets and philharmonic music resounding in its hills, small-town America and the capital of movieland. The amazing pace at which Hollywood rose from agricultural hamlet to sprawling boomtown in a matter of decades was due to the film industry that had settled comfortably in its foothills. The movies reinforced their early reputation for the exotic with boldly

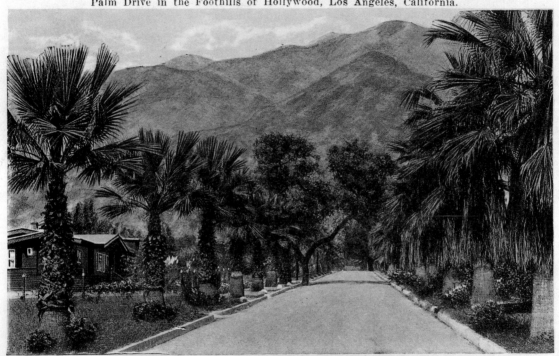

Palm Drive in the Foothills of Hollywood, Los Angeles, California.

Young palms and freshly built bungalows line a street leading to barren hills in an early Hollywood scene.

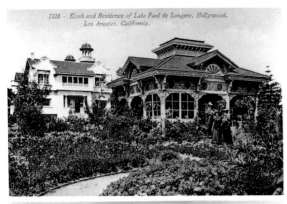

2228 – Kiosk and Residence of Late Paul de Longpre, Hollywood. Los Angeles, California.

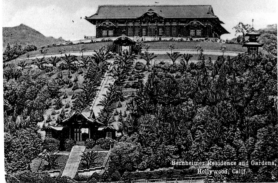

Bernheimer Residence and Gardens, Hollywood, Calif.

Hollywood's first tourist attraction (top), the Moorish residence and studio of watercolorist Paul de Longpre. Adolph and Eugene Bernheimer's Oriental mansion (bottom) was completed in 1914.

erected sets of Babylonian palaces and English castles butted up against bungalows and palm trees.

Prior to the advent of the movies, early residents had set a precedent for eccentric homes, from the Moorish-inspired house and studio of artist Paul de Longpre to the Chinese palace of importers Adolph and Eugene Bernheimer. Others, like Gurdon Wattles, took advantage of the fertile ground and planted elaborate gardens of rare and unusual plantings. The impact of the movies, however, overshadowed any earlier Hollywood claim to fame.

The popularity of the movies took Hollywood by storm. Waves of hopefuls seeking the stardom they thought awaited them helped fill a city already in its first flush of prosperity. Tree-lined Sunset and Hollywood boulevards, once residential streets, gave way to hotels, haberdasheries, and studio back lots. Extravagant estates dotted the hillsides. Dozens of dance and dramatic schools sprouted in former fields, while churches, service clubs, libraries, and hospitals signalled Hollywood's community development. Hollywood Boulevard, the main thoroughfare, became the central business and amusement district. A mixture of sophistication and small town manners, it epitomized the colorful city. Beginning at the corner of Hollywood and Vine, several blocks blossomed with restaurants, nightclubs, playhouses, bowling alleys, and recording studios.

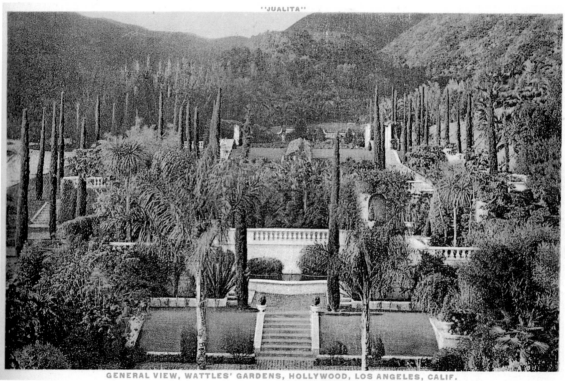

"JUALITA"

GENERAL VIEW, WATTLES' GARDENS, HOLLYWOOD, LOS ANGELES, CALIF.

"Juálita," the garden estate of Omaha businessman Gurdon Wattles, was developed between 1905 and 1909 and was located above Hollywood Boulevard at the end of Franklin Avenue.

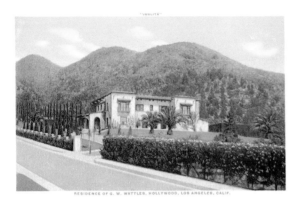

RESIDENCE OF G. W. WATTLES, HOLLYWOOD, LOS ANGELES, CALIF.

As the city and its reputation grew, some of the industry that was responsible for its fame moved to outlying areas, and the term soon stood for any place movies were made or stars congregated. Still the city of Hollywood remained the heartbeat of the movie world and all that was associated with it.

The war years brought a fresh tide of newcomers to the city. No longer were the droves of hopefuls the most visible people in town. Instead men in uniform edged out the sunglasses and slacks. The movie studios were at maximum production and Hollywood buzzed with activity. Entertainment spots were full, and service clubs catered to soldiers on leave. With the postwar years, however, the economy and changing social attitudes drastically altered the city. Hollywood adapted readily to the new phenomenon of television, but the studios suffered the loss of both stars and production. The entertainment scene receded dramatically with the rise of Las Vegas, and the glory of some of Hollywood's brightest streets was dimmed. The golden years of Hollywood had begun to fade, but the hamlet resting against the hills had attained the recognition of the world.

The work of architects Myron Hunt and Elmer Grey, Wattles' garden was an early example of the exotic and rich landscape that became associated with the name Hollywood.

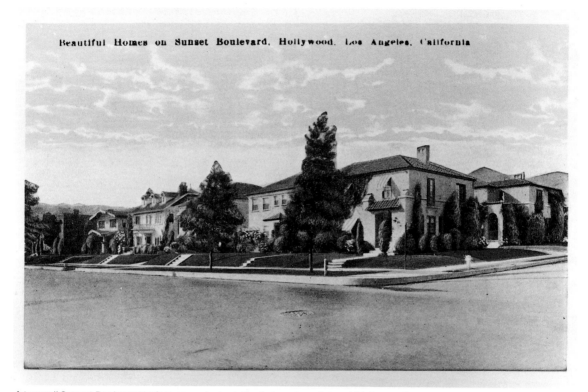

Beautiful Homes on Sunset Boulevard, Hollywood, Los Angeles, California

A tranquil Sunset Boulevard before several population booms transformed it into a major commercial thoroughfare.

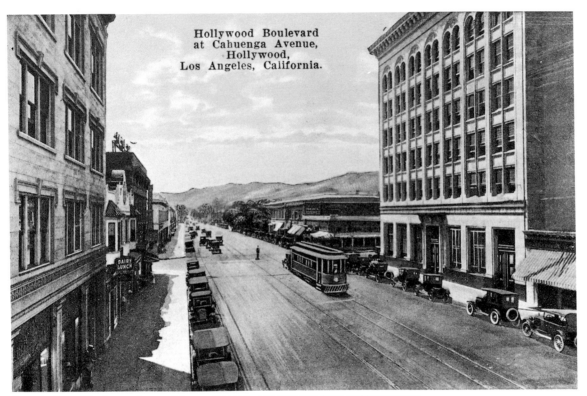

Hollywood Boulevard
at Cahuenga Avenue,
Hollywood,
Los Angeles, California.

*An early view of the former Prospect Avenue looking west when tree-lined residences were
still in evidence.*

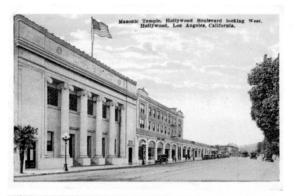

Masonic Temple, Hollywood Boulevard looking West.
Hollywood, Los Angeles, California.

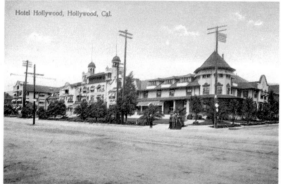

Hotel Hollywood, Hollywood, Cal.

The Masonic Temple on Hollywood Boulevard (top) was built in 1922 across from the soon-to-be constructed Chinese Theatre. The Hollywood Hotel (bottom) was established in 1903 and became a popular rendezvous with the film colony.

Initially a dusty horse trail, Hollywood Boulevard, the community's main thoroughfare, ran from Virgil Street on its eastern terminus to beyond Laurel Canyon on the west. The boulevard gained international acclaim in its heyday when movie stars lived, shopped, and sought entertainment on its pepper tree–lined sidewalks. The commercial heart of Hollywood—fashionable shops, markets, banks, offices, and other services—was found there. One of the earliest movieland landmarks was the Hollywood Hotel, which opened in 1903 and hosted most of the early silent stars on their arrival in town. Thursday-night dances were a focus of social life, and in later years when Louella Parsons broadcast her "Hollywood Hotel" program the hotel became a national institution.

Along this street were the many motion picture theatres, from the exotic palaces of Sid Grauman's Egyptian and Chinese to the ornately appointed Pantages and the majestic Warner Brothers. The scene of an endless parade of premieres, the Boulevard seemed to possess a phalanx of permanently lit klieg lights. Among its more staid edifices, the Masonic Temple lent an air of respectability to the street. Its classic lines were an interesting contrast to the neon dragons and cement footprints of the Chinese Theatre across the street.

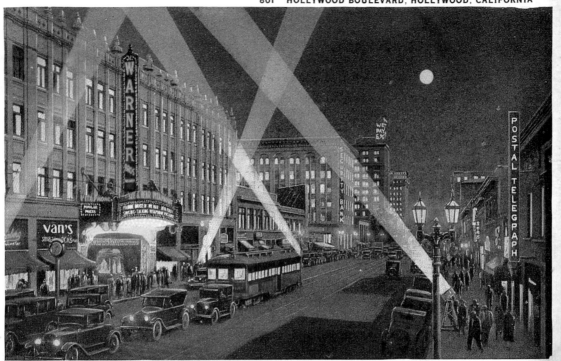

646-29

23

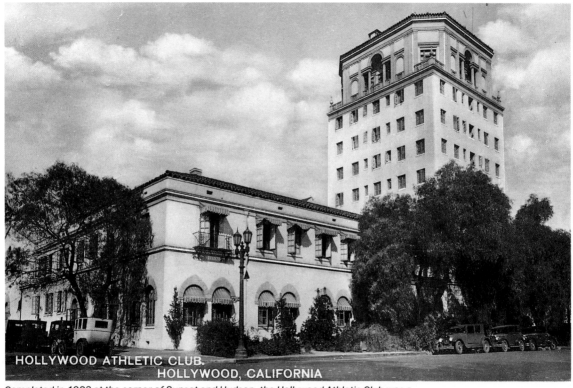

HOLLYWOOD ATHLETIC CLUB.
HOLLYWOOD, CALIFORNIA

Completed in 1923 at the corner of Sunset and Hudson, the Hollywood Athletic Club was a civic meeting place and a residence for male movie stars.

One measure of Hollywood's growth as a metropolitan area was the increase of public facilities for the welfare of the community. The Hollywood Athletic Club, in addition to operating a health club, lodged some of the top male celebrities of Hollywood's golden era. The club was the meeting ground for civic and movie industry leaders, and dances were held in its ballroom. Several hospitals aided the Hollywood area; one of the most enduring was the Hollywood Presbyterian on Vermont. Originally known as Hollywood Hospital, its name was changed in 1937. Hollywood's post office occupied several locations before the modern government building opened on Wilcox in 1937. One of the largest offices in the Southland, it was a testament to the city's population boom.

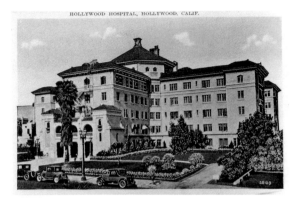

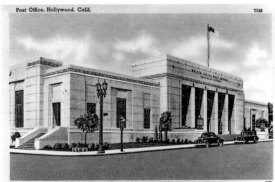

The Hollywood Hospital (top), later renamed Hollywood Presbyterian, was an early sign of community growth. Another addition to the civic image of Hollywood (bottom) was the stripped Classicism of its new post office built in 1937.

The lure of Hollywood created a seemingly endless stream of visitors who came for business and pleasure. Staying in Hollywood provided a chance to glimpse a star and make a pilgrimage to all the places the magazines and newsreels clamored about. The Hollywood Hotel was the earliest hostelry, but in its wake a wave of first-rate accomodations were built along and adjacent to Hollywood Boulevard and surrounding areas. The Christie Hotel led the way for a string of luxury hotels that opened in the twenties. The Hollywood and Vine became a meeting place for radio personalities who broadcast from nearby studios. It attracted a wide variety of entertainers with its roof-garden dances and ground-level It Club owned by Clara Bow. The Hollywood Roosevelt opened in 1927, and from the start it was a smart place to be seen. Russ Columbo broadcast a radio show from the hotel's famed Cinegrill, while the Blossom Room featured dancing on Monday nights with stars in full attendance.

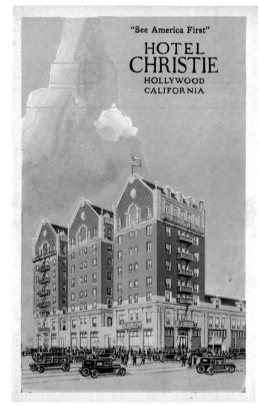

Located at Hollywood Boulevard and McCadden, the Hotel Christie opened in 1923.

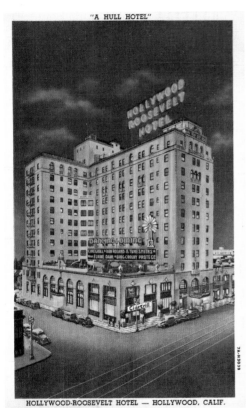

HOLLYWOOD-ROOSEVELT HOTEL — HOLLYWOOD, CALIF.

*Across from Grauman's Chinese Theatre, the
Roosevelt Hotel opened in the same year, 1927.*

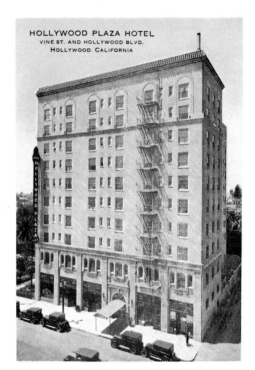

HOLLYWOOD PLAZA HOTEL
VINE ST. AND HOLLYWOOD BLVD.
HOLLYWOOD, CALIFORNIA

Hollywood's Finest Residential and Transient Hotel.
Every room a parlor with dressing room and bath. Strictly fireproof.
Conveniently located in midst of Hollywood's Studios, Theatres and Beach Drives.
Splendid Cafe in Connection.

*The Hollywood Plaza Hotel, another gathering place
for stars, opened in 1925 near Hollywood and Vine.*

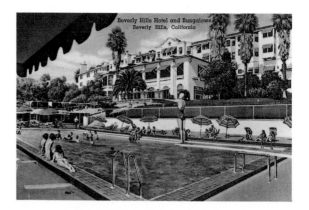

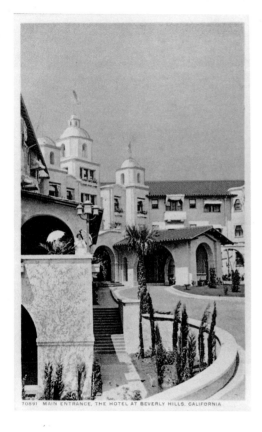

T0891 MAIN ENTRANCE, THE HOTEL AT BEVERLY HILLS, CALIFORNIA

Once considered out of town, the Beverly Hills Hotel quickly became an alternative to Hollywood high living when the former manager of the Hollywood Hotel took over its management. This setting of genteel hospitality became an enviable place for Eastern visitors to winter, with its lush gardens on 16 acres of land. The movie colony heavily patronized the place, and its presence was eventually responsible for establishing the city of Beverly Hills. The addition of the Polo Lounge and the Sand and Pool Club in the thirties made the hotel the hub of social life for all Hollywood.

Designed by Elmer Grey in 1912, the rambling Beverly Hills Hotel was a Mission Revival–style resort on 116 acres of open land.

THE GARDEN OF ALLAH
HOTEL AND VILLAS
8152 SUNSET BOULEVARD • • HOLLYWOOD, CALIF.

The Garden of Allah, built by actress Alla Nazimova in 1921, was home to a veritable who's who of the film colony and the scene of a great deal of Hollywood mischief.

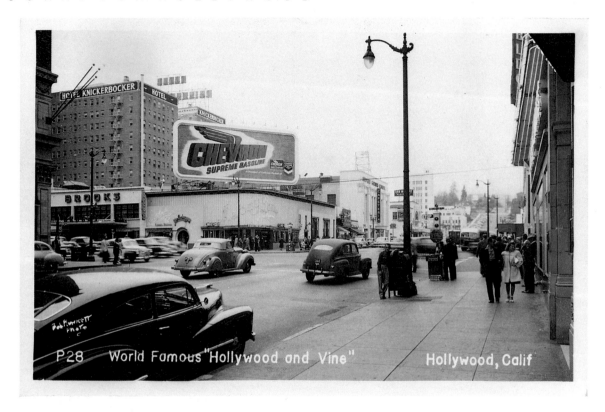

P28 World Famous "Hollywood and Vine" — Hollywood, Calif

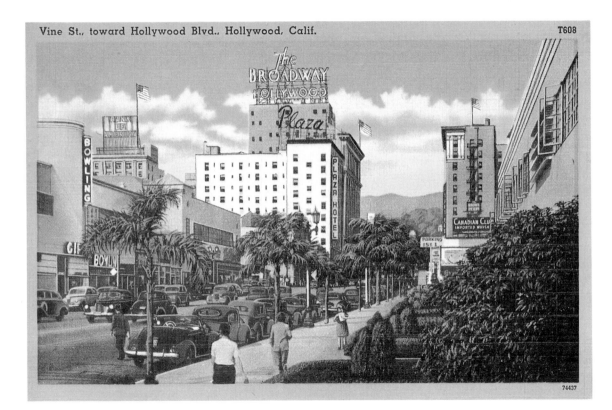

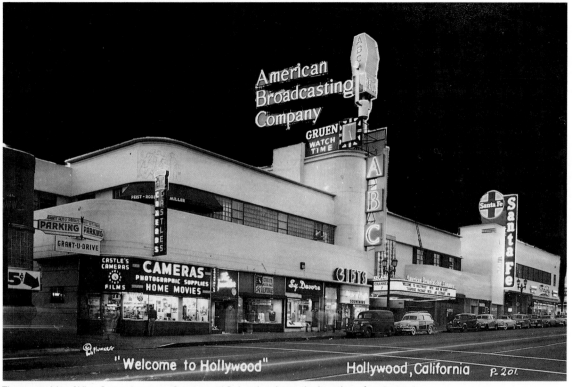

The west side of Vine Street between Sunset and Selma has been the location of restaurants, clubs, a bowling alley, and a record company.

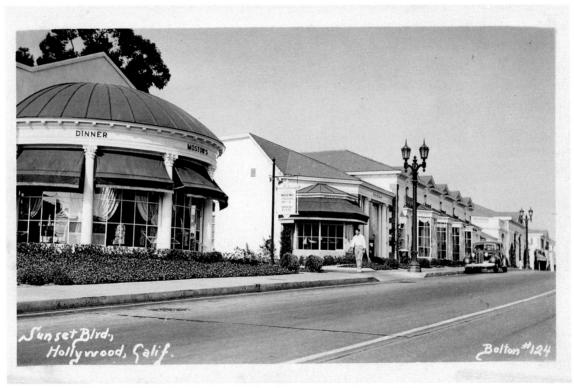

Sunset Blvd.,
Hollywood, Calif.

Bolton #124

Part of the famed Sunset Strip developed as an expensive shopping area in the early 1930s.

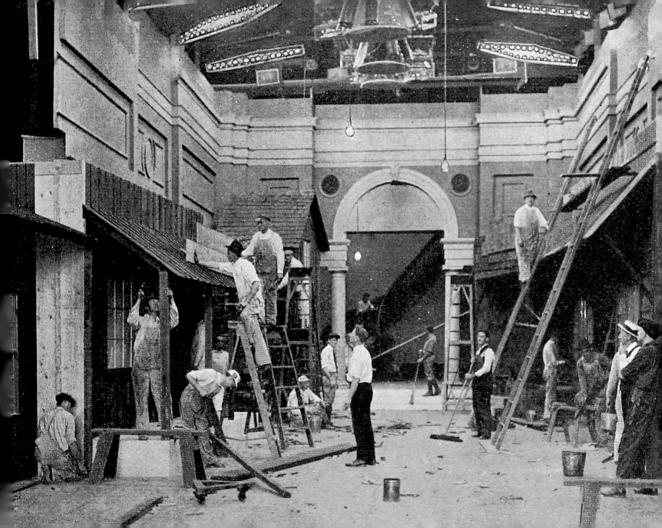

MAKING MOVIES

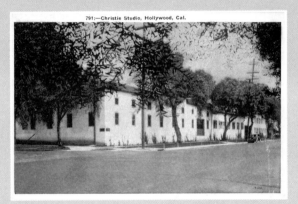

791:—Christie Studio, Hollywood, Cal.

With the founding of Hollywood's first movie studio in 1911, the industry that would become synonymous with the name Hollywood quietly slipped into town, altering forever the tranquility of the Cahuenga Valley. As bean fields gave way to sound stages and sets, moviemaking replaced agriculture as the area's economic base. During days of continual sun, comedians romped through residential streets while cowboys rode through the middle of town, sometimes to

Norma Talmadge at United Studios, Hollywood.

the pleasure but often to the horror of transplanted Midwesterners. The crude equipment used in the early years of filmmaking quickly gave way to a more sophisticated technology, and as the film industry became a billion-dollar business, film companies invested in new ideas and in permanent facilities throughout the Hollywood area.

Although Hollywood was the realm of make-believe, manufacturing films was serious business to studio heads bent on making a profit. The introduction of the full-length picture and the star system created uncontrolled popularity for this new brand of entertainment, and before long the stars themselves were forming film companies. As the industry expanded, thousands of newcomers flocked to Hollywood in hopes of being discovered. Their chances were slim, but some did make it to almost instant stardom.

The introduction of sound ushered in a new era, leaving some studios and stars behind while creating successes of others. Technicolor was the next major advancement in the development of the film medium, and until the introduction of television in the late forties the motion picture reigned.

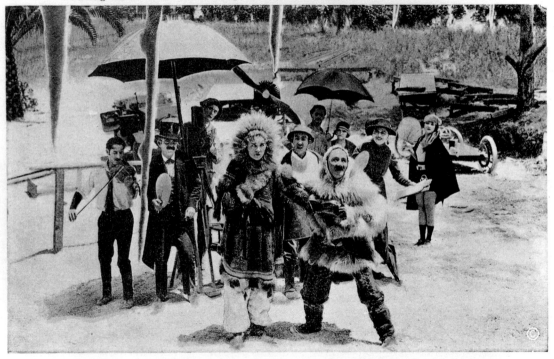

"Faking" a Snow Scene in Tropical California, Mack Sennett Studios, Edendale.

Rodolph Valentino, Gloria Swanson and Elinor Glyn, Paramount Studios, Hollywood.

Buster Keaton in one of his comedies, Hollywood.

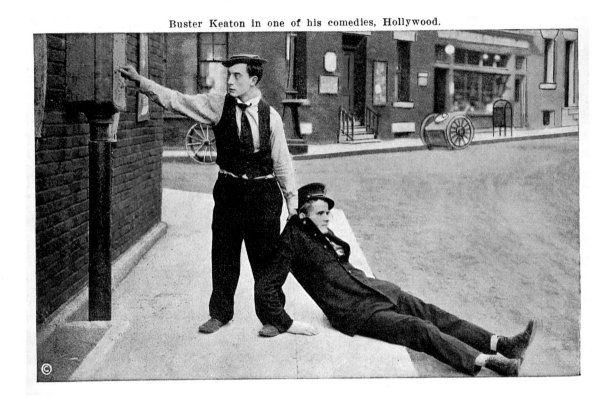

Mary Pickford, Pickford-Fairbanks Studios, Hollywood, California.

The Pickford-Fairbanks studio was opened in 1922 at 7200 Santa Monica Boulevard, where two of the silent era's most famous epics were filmed: The Thief of Baghdad *and* Robin Hood.

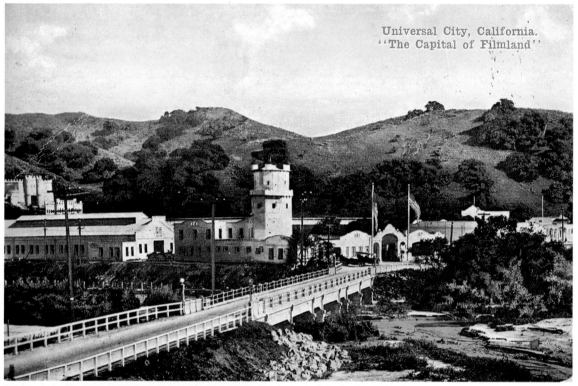

Universal City, California.
"The Capital of Filmland"

Lankersheim Boulevard passes in front of Universal City in what was then the rugged country of San Fernando Valley.

Carl Laemmle's Universal Film Manufacturing Company was formed in May 1912 by the acquisition of the Nestor Film Company on the site of Hollywood's first studio at Sunset and Gower. In 1915 Laemmle moved his company over the Cahuenga Pass and founded Universal City on leased San Fernando Valley ranchlands that he later purchased. In this independent municipality of 235 acres, such films as *Dracula, Frankenstein, All Quiet On The Western Front,* and *Imitation of Life* were shot. One of the few studios to allow visitors as a matter of policy, Universal in its early days had grandstands where tourists could watch movie filming for 25 cents. Also on the lot was a public restaurant called Dine with the Stars.

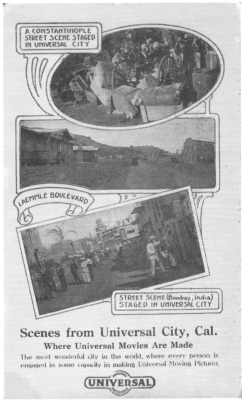

Scenes from Universal City, Cal.
Where Universal Movies Are Made
The most wonderful city in the world, where every person is engaged in some capacity in making Universal Moving Pictures

Universal Studios was one of the few film factories to allow visitors a chance to see movies being made.

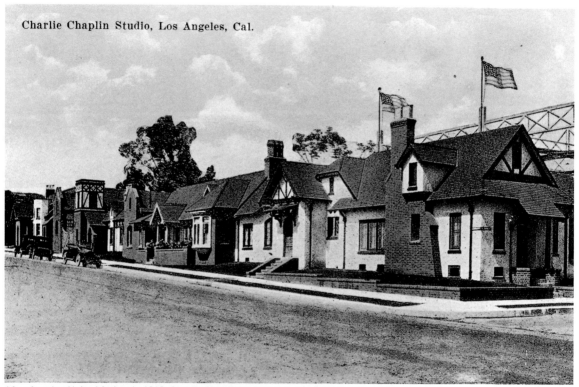

Charlie Chaplin Studio, Los Angeles, Cal.

After forming United Artists in 1919, Charlie Chaplin built his studio near the intersection of Sunset and LaBrea, a compound that at one time included his residence.

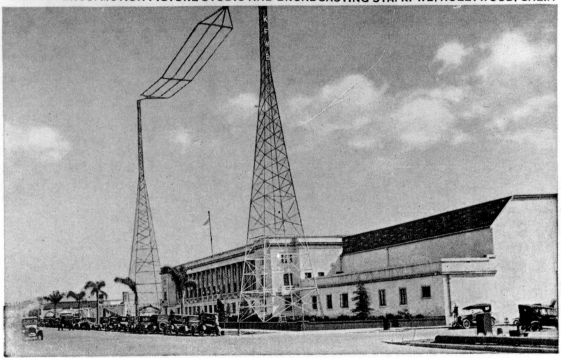

The colonnaded facade of Warner Brothers studio on Sunset near Bronson was, at its height, the largest facility of its kind on the West Coast. In the forties it housed a fifty-two lane bowling alley. Currently it is home to Gene Autry's Golden West Broadcasting.

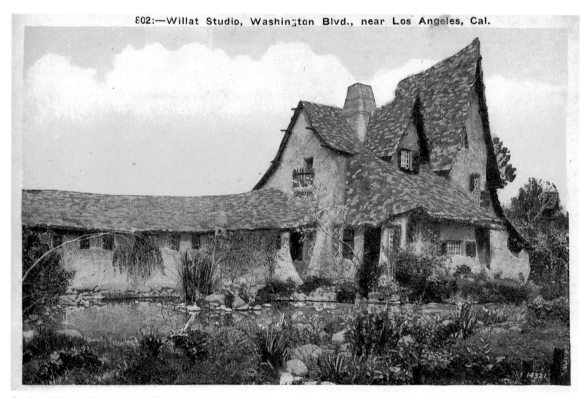

802:—Willat Studio, Washington Blvd., near Los Angeles, Cal.

Designed by art director Harry Oliver, Irving Willat's studio was situated in a cluster of film factories in Culver City. Moved in 1931, it is now a Beverly Hills residence.

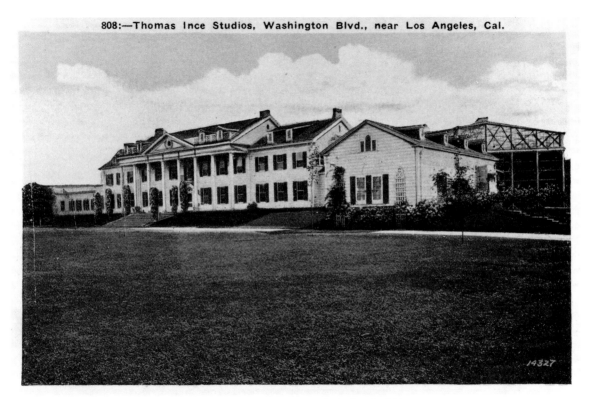

808:—Thomas Ince Studios, Washington Blvd., near Los Angeles, Cal.

Originally built as a set, Thomas Ince's studio saw numerous owners including Cecil B. De Mille, Pathe, RKO, and Selznick International.

FOX STUDIOS AT WESTWOOD, CALIF.

A-97

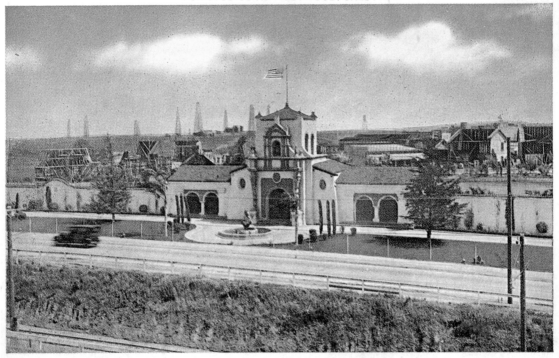

Upon moving west, William Fox's studio settled in Hollywood on Western Avenue. Its amazing growth necessitated larger production facilities, and in 1923 the studio moved to 250 acres west of Beverly Hills between Santa Monica and Pico boulevards.

The home of Clara Bow, Mae West, and countless other stars, Paramont moved to its Mara-thon Avenue lot in 1926. Its prior location, as Famous Lasky Players, was at Sunset and Vine.

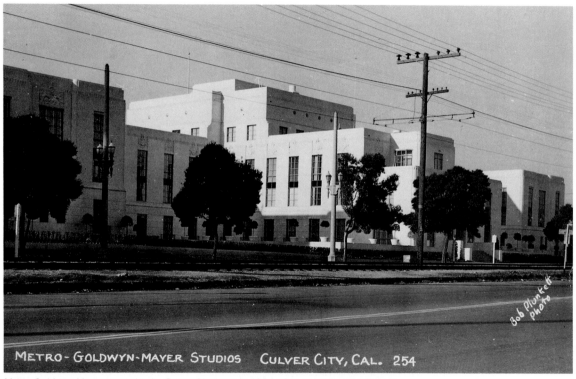

METRO-GOLDWYN-MAYER STUDIOS CULVER CITY, CAL. 254

Bob Plunkett photo

Metro-Goldwyn-Mayer moved to its Culver City base in 1924 after acquiring the former Triangle Pictures lot. The Thalberg Building, pictured, was completed in 1938–39.

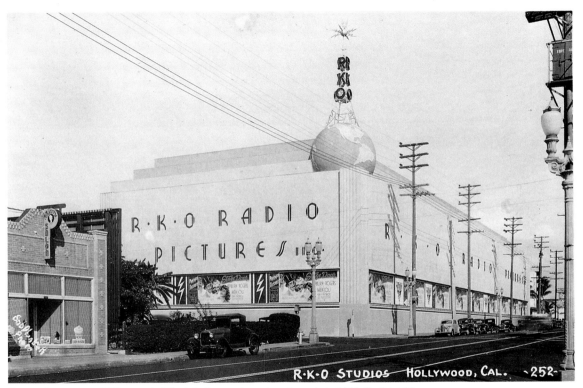

Next to Paramount, RKO occupied the lot of several previous tenants in 1931. By the mid-thirties the familiar globe at Gower and Melrose was a local landmark.

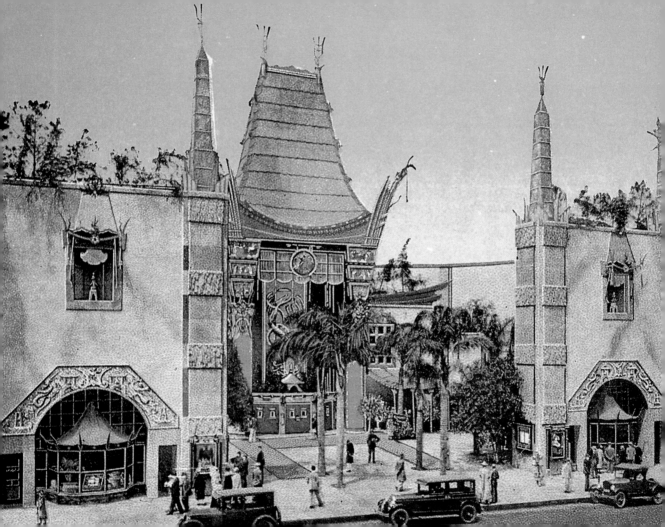

PLAYGROUND OF THE STARS

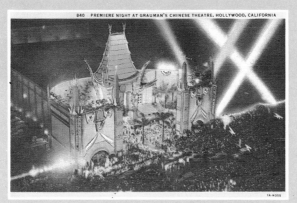

840 PREMIERE NIGHT AT GRAUMAN'S CHINESE THEATRE, HOLLYWOOD, CALIFORNIA

Few cities of the world could compare with the kind of diversions boasted by the capital of filmland. Early on the social scene centered around the Holly-wood Hotel, then expanded as rapidly as the industry that supported it. The Ambassador Hotel's Coconut Grove, as well as the Cage Montmartre, offered high-spirited dancing in glamorous settings with prices to match, while concerts and legitimate theatre were available within blocks of each other on Hollywood

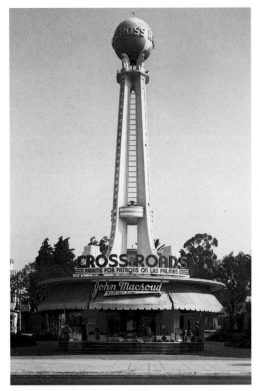

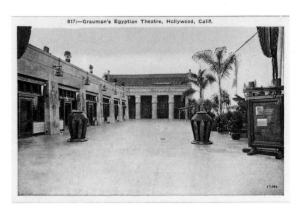

Boulevard. Farther west, stars off duty were tempted into the dark depths of Sunset Strip night spots named Mocambo, Trocadero, Ciro's and Players.

If the choices seemed alluring to the stars, to visitors the prospects must have seemed limitless. Radio show broadcasts and miniature golf, cocktails and sunning poolside, bowling, ice skating, and baseball games were all within easy reach of the tourist in Hollywood. As if that weren't enough, premieres, gambling dens, drive-ins, and even a spot where a thousand monkeys ran loose provided even the most jaded thrill seeker excuses to send postcards to the folks back home.

Crossroads of the World, designed by Robert Derrah, opened October 29, 1936, and was an eclectic mixture of architectural styles arranged around a pedestrian mall.

The Hollywood premiere originated at Sid Grauman's Egyptian Theatre, which opened in 1921.

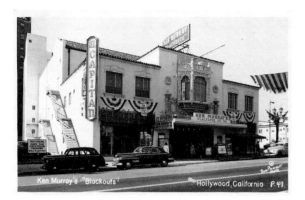

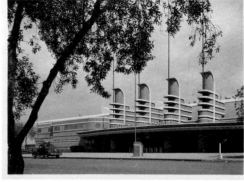

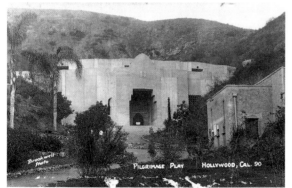

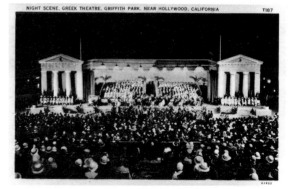

Originally a legitimate theatre, the Hollywood Playhouse (top left) later became the El Capitan, home of Ken Murray's Blackouts. A landmark streamlined building, the Pan Pacific (top right) housed ice shows and expos when it opened in

1935. The site of a yearly religious play, the Pilgrimage Theatre (bottom left) opened in 1921 and is now a cultural arts center. Completed in 1930 in Griffith Park, the Greek Theatre (bottom right) is still used for cultural events.

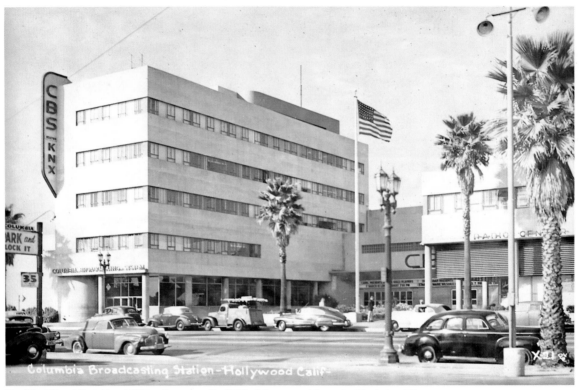

The West Coast flagship of CBS radio opened in 1938 at Gower and Sunset with state-of-the-art facilities. Columbia still operates broadcasting studios there.

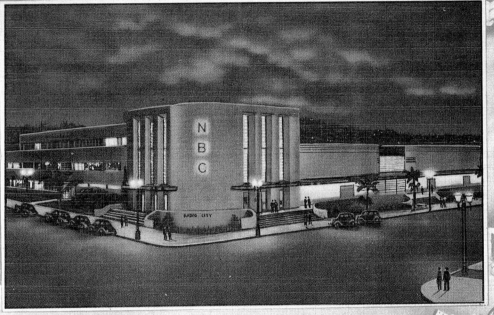

Greetings FROM HOLLYWOOD

123:-NBC RADIO CITY BY NIGHT, CORNER SUNSET AND VINE,
HOLLYWOOD, CALIFORNIA

*Several blocks to the west of CBS, NBC operated its modern studios at the corner of Sunset
and Vine. Built in 1938, it stood on the former Jesse Lasky Studios site.*

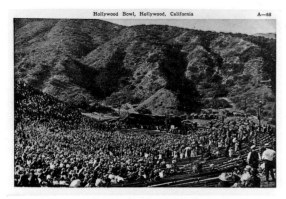

Hollywood Bowl, Hollywood, California A—58

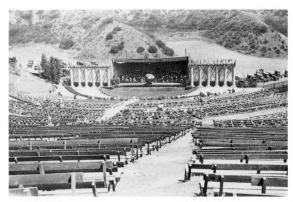

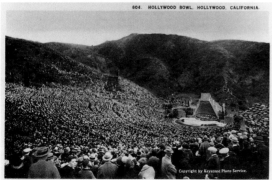

804. HOLLYWOOD BOWL, HOLLYWOOD, CALIFORNIA.

Copyright by Keystone Photo Service.

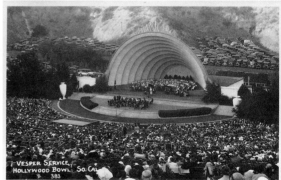

VESPER SERVICE
HOLLYWOOD BOWL, So. Cal.
383

Besides a canvas stage and wooden seating, litle else existed at the early Hollywood Bowl (top left). By 1925 the Bowl's growth was evident in improved stage facilities (top right). Lloyd Wright designed the Bowl's stylized shell for the 1927 season (bottom left). The familiar half-shell shape of the current Hollywood Bowl (bottom right) was erected in 1929.

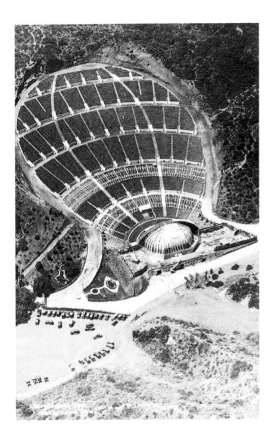

In an attempt to bring culture to Hollywood, several community boosters promoted the use of a site known as Daisy Dell to present plays and other cultural activities. By 1920 performances in the natural amphitheatre were under way among shrubs and undergrowth. Its immediate popularity led to improvements and a variety of stage designs. Beginning with a canvas canopy and hastily built seats, the Hollywood Bowl acquired a more permanent look with a wooden stage flanked by columns. In 1927 Lloyd Wright was commissioned to create a shell. His triangular design was used for one season. The following year he designed a more esthetically pleasing shell that became the basis for the structure now in use.

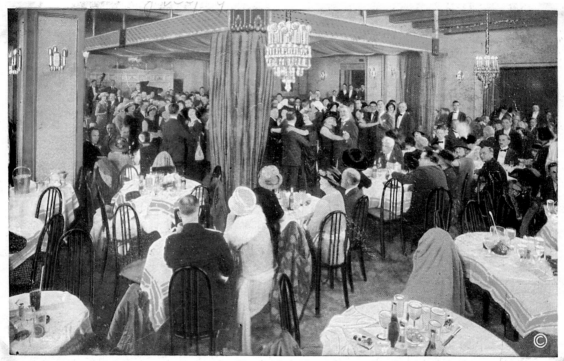

BRANDSTATTER'S CAFE MONTMARTRE IN HOLLYWOOD

The site of early celebrity revelry, the Montmartre entertained Hollywood's brightest stars in the twenties.

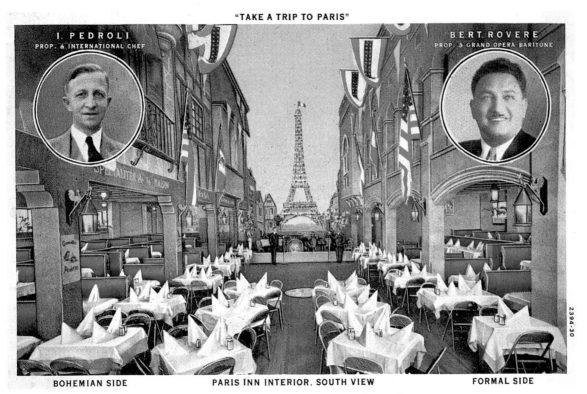

"TAKE A TRIP TO PARIS"

I. PEDROLI
PROP. & INTERNATIONAL CHEF

BERT ROVERE
PROP. & GRAND OPERA BARITONE

BOHEMIAN SIDE PARIS INN INTERIOR, SOUTH VIEW FORMAL SIDE

The movie crowd that trekked downtown Los Angeles made the Paris Inn a Hollywood hangout for years after it opened on New Year's Eve in 1925.

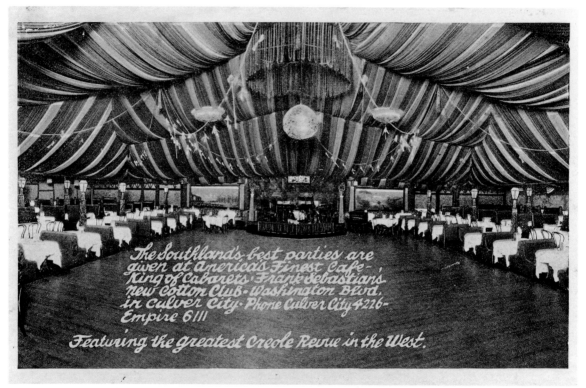

Near the studios of Culver City, Frank Sebastian's Cotton Club on a rowdy strip of Washington Boulevard was a showcase for early jazz bands and entertainers catering to the movie star trade.

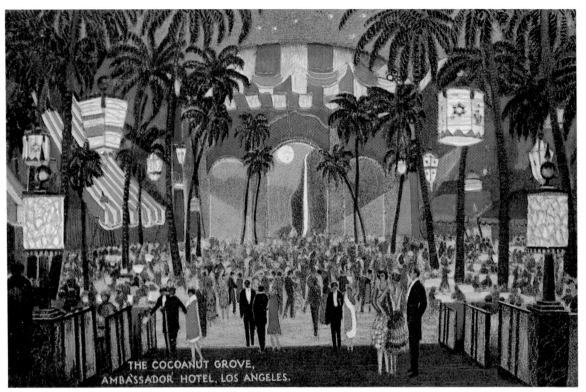

THE COCOANUT GROVE,
AMBASSADOR HOTEL, LOS ANGELES.

One of the most glamorous of Hollywood institutions, the Coconut Grove spanned several decades playing host to the Academy Awards and star-studded Tuesday night dances.

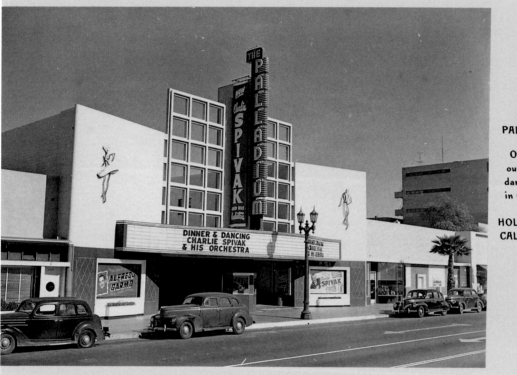

THE
PALLADIUM

One of the
outstanding
dance places
in the world

HOLLYWOOD
CALIFORNIA

F4258

*Situated between CBS and NBC, the Palladium was the spot to hear the Big Bands. Designed
by Gordon Kaufman in 1940, it was another favorite with movie stars.*

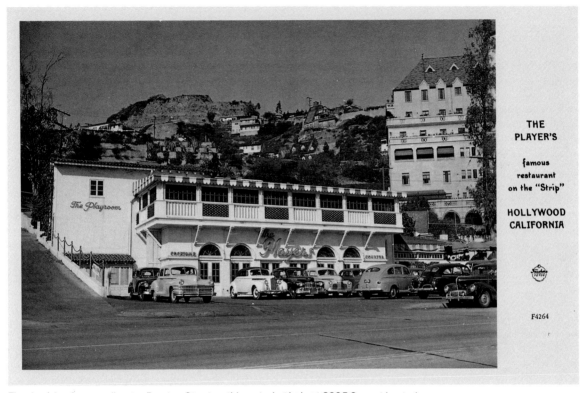

The domain of owner-director Preston Sturges, this watering hole at 8225 Sunset hosted screen stars and the literary crowd from the Garden of Allah across the street.

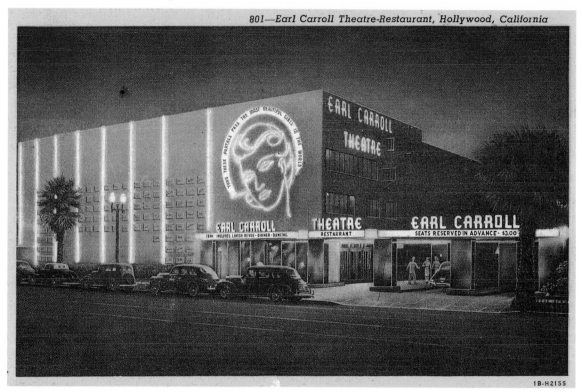

The creation of Earl Carroll, this theatre featured a patent leather ceiling, a revolving stage, and a lavish revue. It opened near Sunset and Vine in 1938.

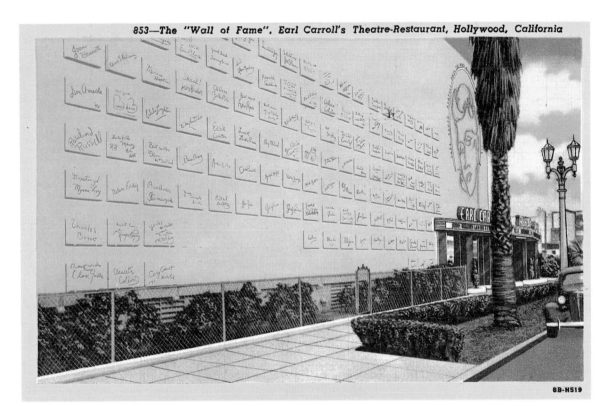

853—The "Wall of Fame", Earl Carroll's Theatre-Restaurant, Hollywood, California

8B-H519

Inspired by the forecourt of Grauman's Chinese Theatre, Earl Carroll's "Wall of Fame" posted the names of the famous on concrete blocks.

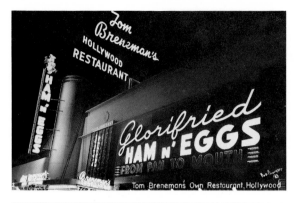

One of the three major nightclubs on the Strip, Ciro's drew a choice crowd and national attention. It was equipped with its own publicist, and in the forties owner Herman Hover spent $125,000 a year promoting the establishment. His efforts paid off, and the flow of celebrities never ended until the club closed in 1957. The showplace was redecorated every two years to assure an easily jaded clientele a new atmosphere. The house band was often Xavier Cugat, and postpremiere parties, benefits, industry meetings, trysts, and fights were all hosted in the intimate confines of one of the most famous of Hollywood nightclubs.

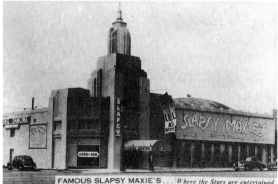

Tom Breneman's "Breakfast Club" broadcasts from his Vine Street restaurant (top) drew lines around the block during the forties. The fun palace of "Slapsie Maxie" Rosenbloom was located on Wilshire Boulevard south of Hollywood (bottom).

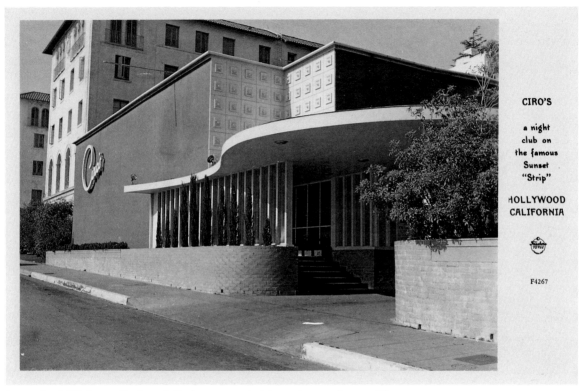

CIRO'S

a night
club on
the famous
Sunset
"Strip"

HOLLYWOOD
CALIFORNIA

F4267

Located at 8433 Sunset Boulevard, Ciro's was an entertainment mecca for over fifteen years.

843—The Rendezvous of the Stars, The Brown Derby, Hollywood, California

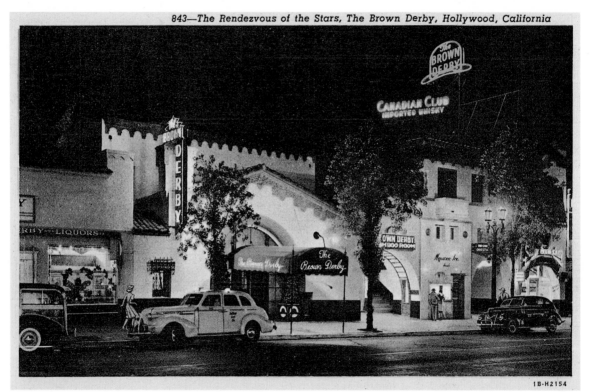

The Hollywood Brown Derby has been hosting celebrities since 1926, when being paged became a ritual and having your caricature on the wall was a sign of instant stardom.

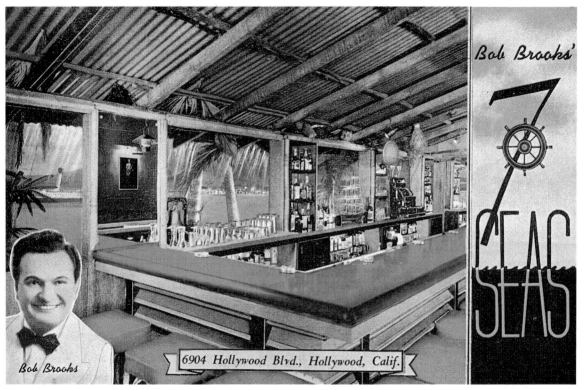

Bob Brooks' Seven Seas was a tropical paradise opposite the Chinese Theatre on Hollywood Boulevard. Famous for its "Rain on the Roof," it featured native floor shows and Hawaiian music.

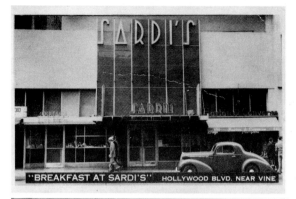

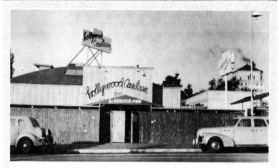

FAMOUS HOLLYWOOD CANTEEN, HOLLYWOOD, CALIF.

A mecca for servicemen during Hollywood's war years, the Hollywood Canteen was the spot most frequented by men in uniform. Opened in October 1942, the Canteen was founded by Bette Davis and John Garfield and was supported by virtually every entertainer in Hollywood. Marlene Dietrich, Betty Grable, Deanna Durbin, Greer Garson, Rita Hayworth, and many more worked at the snack bar, bussed dishes, served food, sang, and danced—all for free. Music was by top-name bands, studio secretaries typed letters for the folks back home, and cigarettes, coffee, sandwiches, and milk were for the asking. With 100,000 visitors monthly, the Hollywood Canteen became the most enduring memory legions of servicemen took home from Hollywood.

Designed by R. Schindler, ultra-modern Sardi's restaurant (top) opened in 1933 near Hollywood and Vine. From 1942 to 1945 the Hollywood Canteen (bottom) hosted servicemen on Cahuenga Boulevard just south of Sunset.

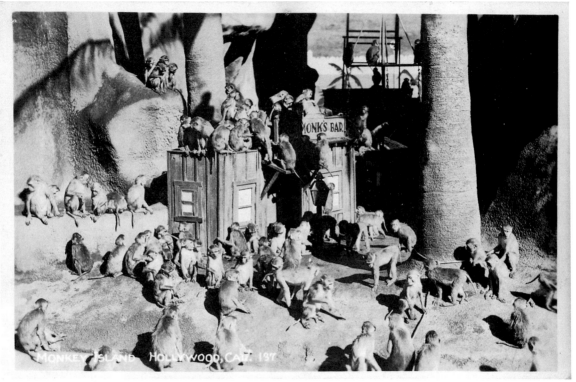

"Three magnificent acres of continuous entertainment with a chimpanzee show every half hour" was the way Monkey Island was billed when it was located at 3300 Cahuenga Boulevard. Visitors were treated to one thousand monkeys running loose in one of Hollywood's truly bizarre attractions.

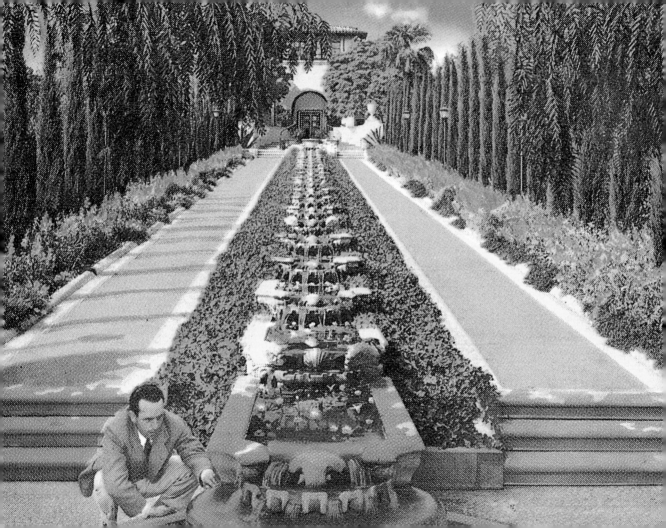

HOMES OF THE STARS

*Hollywood Official Tourist Guide Service, 2138 Cahuenga Blvd.
"Highway 101" Gladstone 5419. Hollywood, Calif.*

From the modest bungalows constructed by the silent stars to the sprawling estates of later film legends, a guided tour of the great homes of Hollywood was a must to any visitor. A glimpse of the dream world in which the favored stars spent their home life was a thrill few could pass up. Any expectations tourists had of a movie star's life were more than realized in the garish, exotic, and massive edifices the new royalty chose as their domiciles. The most impressive

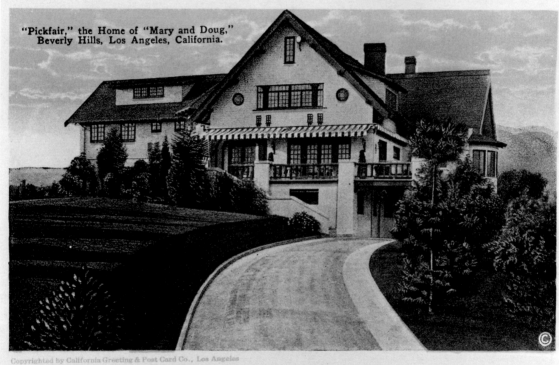

"Pickfair," the Home of "Mary and Doug,"
Beverly Hills, Los Angeles, California.

Copyrighted by California Greeting & Post Card Co., Los Angeles

of them all was Harold Lloyd's incredible 40-room Greenacres. A staff the size of an army tended twelve formal gardens, 26 bathrooms, a nine-hole golf course, a hundred-seat theatre, an 880-foot-long lake, and countless other amenities. His children played in a miniature thatched cottage with custom-made furniture and running water.

The wealth lavished on homes on a smaller scale was also impressive. Tennis courts and swimming pools were obligatory props, and architectural styles ranged from the sophisticated moderne home of Marlene Dietrich to the oddly medieval-looking house once owned by Charlie Chaplin. Six-car garages, kennels, stables, and small zoos occupied the grounds of other homes in the canyons and hills.

Paralleling the growth of the movie industry, the homes of the stars were first located near the wealthier sections of Los Angeles, moving to Hollywood as the industry prospered. The size and extravagance of the homes grew with the size of their owner's salaries. As Hollywood prospered in the boom years, the ever-westward migration pushed homes into Beverly Hills and Bel Air. The quest for privacy and escape led stars to eventually move into the San Fernando Valley and farther hinterlands where they could pass their valued spare time behind walls and floodlit iron gates.

While some stars maintained a low profile, others fulfilled the public's expectations of how a star should

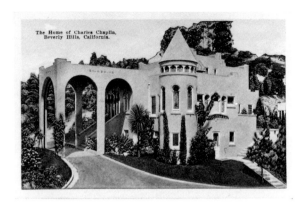

The Home of Charles Chaplin, Beverly Hills, California.

live. Producers and directors also joined in the game, lining their walls with oak paneling, velvet drapes, antique armor, and anything vaguely French, generally following the dictates of what was supposed to signal swanky upper class. Others let studio personnel design their homes and interiors, which yielded some surprisingly smart results. Some, like Tom Mix, let their ego be their guide and erected neon initials atop their homes. Almost anything money could buy ended up in the homes of the stars. Valentino's bedroom was instantly scented when he flicked on the light switch. The screening room of director Thomas Ince was made to

820:—Rudolph Valentino Home, Whitley Heights, Hollywood, Calif.

17990

look like the deck of a pirate ship. Colored fountains, massive bathtubs, gold fixtures—nothing was beyond a price tag.

The fantasy world concocted by Hollywood's stars never disappointed the eager fans and curious tourists, even if their only contact was slowly passing the hedges and gates surrounding the great houses. At least they had seen a land where dreams came true.

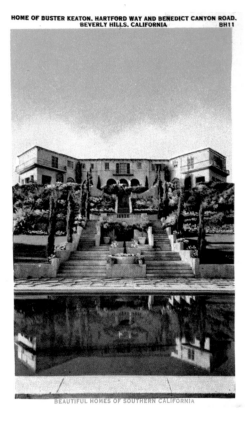

HOME OF BUSTER KEATON. HARTFORD WAY AND BENEDICT CANYON ROAD. BEVERLY HILLS, CALIFORNIA BH11

BEAUTIFUL HOMES OF SOUTHERN CALIFORNIA

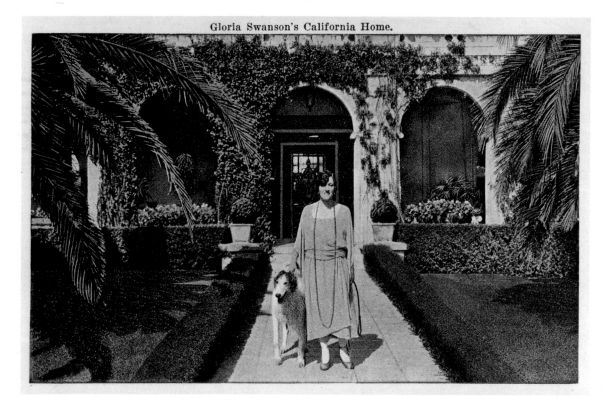

Gloria Swanson's California Home.

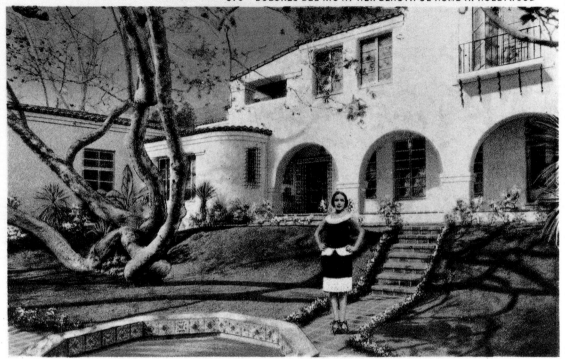

1A-H437

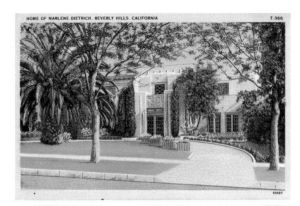

HOME OF MARLENE DIETRICH, BEVERLY HILLS, CALIFORNIA — T-366

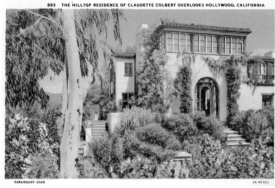

883 THE HILLTOP RESIDENCE OF CLAUDETTE COLBERT OVERLOOKS HOLLYWOOD, CALIFORNIA

PARAMOUNT STAR

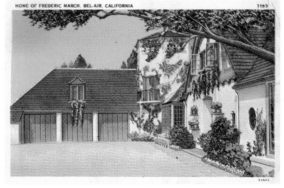

HOME OF FREDERIC MARCH, BEL-AIR, CALIFORNIA — T-193

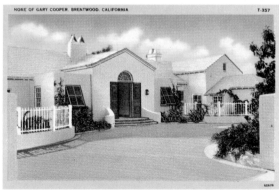

HOME OF GARY COOPER, BRENTWOOD, CALIFORNIA — T-357

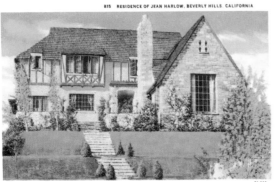

815 RESIDENCE OF JEAN HARLOW, BEVERLY HILLS, CALIFORNIA

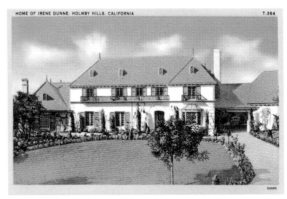

HOME OF IRENE DUNNE, HOLMBY HILLS, CALIFORNIA T-364

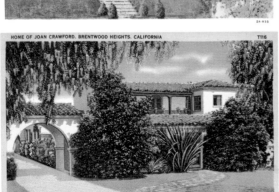

HOME OF JOAN CRAWFORD, BRENTWOOD HEIGHTS, CALIFORNIA T116

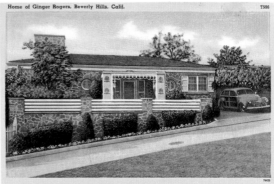

Home of Ginger Rogers, Beverly Hills, Calif. T596

85

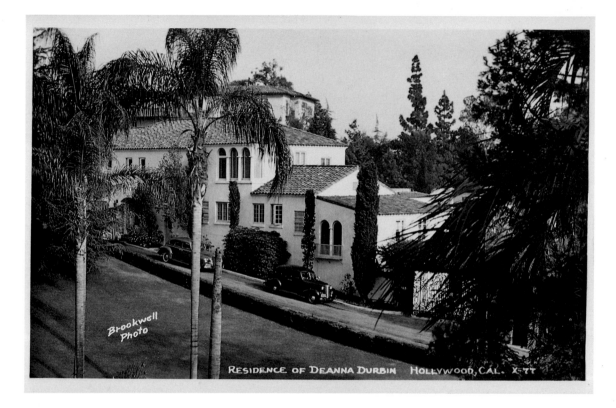

Brookwell
Photo

RESIDENCE OF DEANNA DURBIN HOLLYWOOD, CAL. X-77

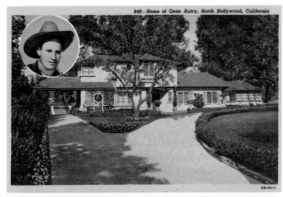

845—Home of Gene Autry, North Hollywood, California

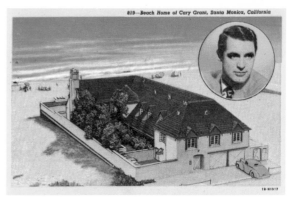

819—Beach Home of Cary Grant, Santa Monica, California

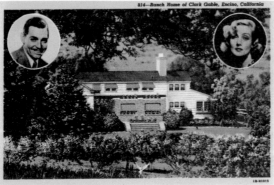

814—Ranch Home of Clark Gable, Encino, California

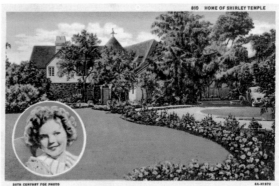

810 HOME OF SHIRLEY TEMPLE

20TH CENTURY FOX PHOTO

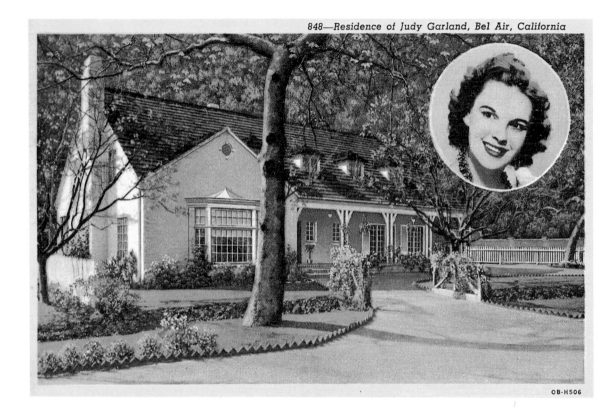

848—Residence of Judy Garland, Bel Air, California

OB-H506

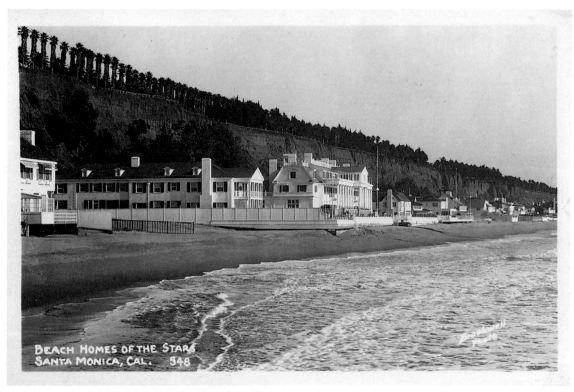

BEACH HOMES OF THE STARS
SANTA MONICA, CAL. 548

Marion Davies' beachfront home in Santa Monica was the epitome of star extravagance.
Several million dollars were spent building and furnishing the edifice, which extended across
750 feet of oceanfront property.

In 1928 the Malibu Ranch of the Rindge family was made accessible to the public with the opening of Roosevelt Highway. Several years earlier, movie star Anna Nillson started the flow of movie stars to the strip of beach that developed into the Malibu movie colony. The exclusive property became a haven and escape for harried stars, and its guard house kept annoying fans at bay. The beach house trend was a natural for a city so close to the sea.

Many stars in the early thirties preferred their "cottages" closer to the studios, and the area north of Santa Monica was also heavily concentrated with stars' second homes. Perhaps the most obvious was the villa William Randolph Hearst built for Marion Davies and which often accommodated two thousand guests for her lavish parties. Built at a cost of $7 million in 1928, it contained 118 rooms and 55 baths, and the huge pool between the house and the beach was crossed by a Venetian bridge.

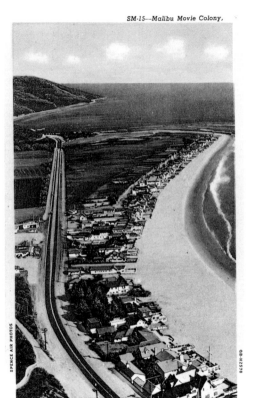

SM-15—Malibu Movie Colony,

Roosevelt Highway near Santa Monica, California

B I B L I O G R A P H Y

Basten, Fred. *Beverly Hills, Portrait of a Fabled City.* Los Angeles: Douglas-West Publishers, 1975.

Brownlow, Kevin. *Hollywood: The Pioneers.* New York: Alfred A. Knopf, 1979.

Cini, Zelda, and Crane, Bob. *Hollywood: Land and Legend.* Westport, Connecticut: Arlington House, 1980.

Gebhard, David. *Schindler.* Salt Lake City: Peregrine Smith, 1980.

Gebhard, David, and Von Breton, Harriette. *L.A. in the Thirties.* Salt Lake City: Peregrine Smith, 1975.

Gebhard, David, and Winter, Robert. *A Guide to Architecture in Los Angeles and Southern California.* Salt Lake City: Peregrine Smith, 1977.

Gleye, Paul. *The Architecture of Los Angeles.* Los Angeles: The Knapp Press, 1981.

Haver, Ronald. *David O. Selznik's Hollywood.* New York: Alfred A. Knopf, 1980.

Henstell, Bruce. *Los Angeles, An Illustrated History.* New York: Alfred A. Knopf, 1980.

Lockwood, Charles. *Dream Palaces.* New York: The Viking Press, 1981.

Los Angeles, A Guide to the City and Its Environs. New York: Hastings House, 1951.

Monahan, Valerie. *An American Postcard Collector's Guide.* Dorset, England: Blandford Books Ltd., 1981.

Torrence, Bruce. *Hollywood, the First 100 Years.* Hollywood: Hollywood Chamber of Commerce/Fiske Enterprises, 1979.

Wurman, Richard Saul. *L.A./Access.* Los Angeles: Access Press, 1980.

I N D E X

© THE LATE RUDOLPH VALENTINO MOUNTED ON JADAAN 114111